OUR SONGBIRDS

A SONGBIRD FOR EVERY WEEK OF THE YEAR

MATT SEWELL

EBURY
PRESS

5 7 9 10 8 6 4

Published in 2013 by Ebury Press, an imprint of Ebury Publishing

A Random House Group Company

Text and illustrations © Matt Sewell 2013

Matt Sewell has asserted his right to be identified as the author of this
Work in accordance with the Copyright, Designs and Patents Act 1988

The Random House Group Limited Reg. No. 954009

Addresses for companies within the Random House Group can be
found at www.randomhouse.co.uk

A CIP catalogue record for this book is available from the British Library

The Random House Group Limited supports the Forest Stewardship
Council® (FSC®), the leading international forest-certification
organisation. Our books carrying the FSC label are printed on
FSC®-certified paper. FSC is the only forest-certification scheme
supported by the leading environmental organisations, including
Greenpeace. Our paper procurement policy can be found at
www.randomhouse.co.uk/environment

To buy books by your favourite authors and register for offers visit
www.randomhouse.co.uk

Printed and bound in Italy by Printer Trento S.r.l.

ISBN 9780091951603

CONTENTS

Foreword by Tim Burgess 5

Introduction 7

The Birds 8

Spotting and Jotting 116

Acknowledgements 128

Dedicated to the memory of Bill, Bob, Kath & Jenny

FOREWORD

If there's one type of bird I have a strong
affinity with, it's definitely the singy songy
fellas. They kind of wake up the world with
their vocals. It's a little known fact, but that's
not them getting up, you know; it's them
having not been to bed yet. Often they've had
a drink, too. They're feathery show offs. Who
cares that an albatross has got the biggest set
of wings – those dudes are bad luck. Nope,
believe me, it's the songbirds that are the
open-beaked frontmen of the feathered world.
Long may they rock . . .

Tim Burgess, The Charlatans
October 2012

INTRODUCTION

Birdsong is a part of the natural stereo
soundtrack to our everyday lives. Some songs
stop us in our tracks with their warmth and
dexterity, but mostly the quacks, clucks, trills,
tweets, kronks, peeps, zing pings, keee-orrs
and crowings go ignored or unnoticed. Sadly,
some of these songs aren't half as common as
they used to be, whilst some songs are growing
in popularity day by day. The sound of birds is
all around us; we just have to stop and listen.

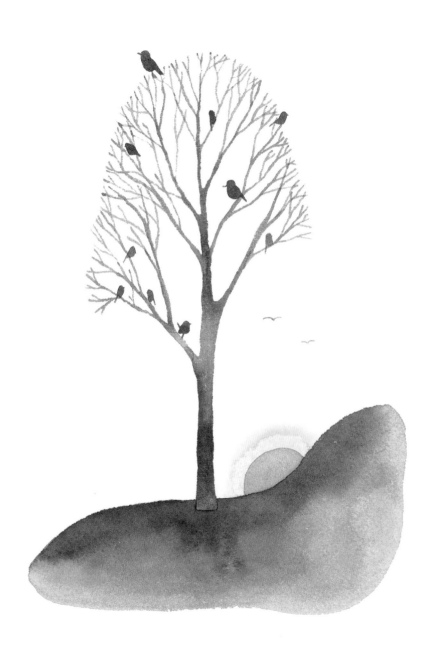

DAWN CHORUS

Not a music television presenter, though I did actually have a music teacher at school called Mrs Melody. An hour before the sun rises over the horizon in spring, the woodland choirs stir and warm up their vocal cords and the misty morning air with songs and sine waves of every shape and colour. Throughout the season each choir grows with newly arrived migrant visitors, building dense layer upon layer and eventually creating a cacophony of industrial proportions. A heady brew that we mainly just sleep through.

Scientists can't explain the Dawn Chorus as it doesn't seem to serve much purpose or practicality; I doubt they ever will either, as they can't logically explain that the birds are full of the joys of spring and so glad to be alive that they sing their songs to the rising sun with gusto.

Lapwing
Vanellus vanellus

Once a common voice within our aural
landscape, the call of the Lapwing was heard
loud and clear throughout British arable lands,
meadows and marshes. So common a sound,
in fact, that many people know this handsome
plover, resplendent in a green and black
iridescent smoking jacket, by his call alone:
the 'peewit'.

It's an instantly recognisable call that matches
his distinguished look and territorial acrobatic
aerial displays. Due to changes in farming
techniques and increased use of pesticides,
Lapwing numbers have hit crisis level,
dropping disastrously in the last thirty years.
That is why the peewit sings the blues.

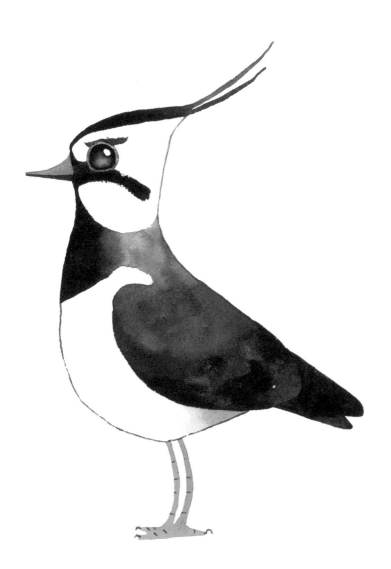

Bittern
Botaurus stellaris

Deep in the marshlands, far beyond where
any Coot or Moorhen dares to tread, dwells
a creature part myth and part Heron; a bird
rarely seen but widely talked of in hushed
tones, as if the slightest movement ten miles
away will push him deeper into the fen. Every
spring the male stealthily makes his way
through the reeds to a clearing at the water's
edge and releases his guttural sonic 'boom'.
Like the sub-bass of an illegal rave, the boom
can be heard through the countryside for up
to a mile. The Bittern huffs in air, filling his
neck like a pair of tweed bellows, and in a
controlled bark gently releases the sound in the
hope of arousing a lady Bittern, who is just as
clandestine and shy as her beau with the boom.

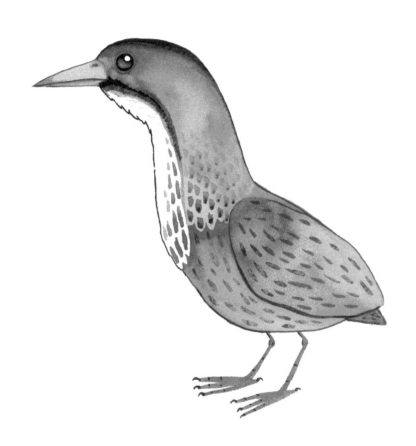

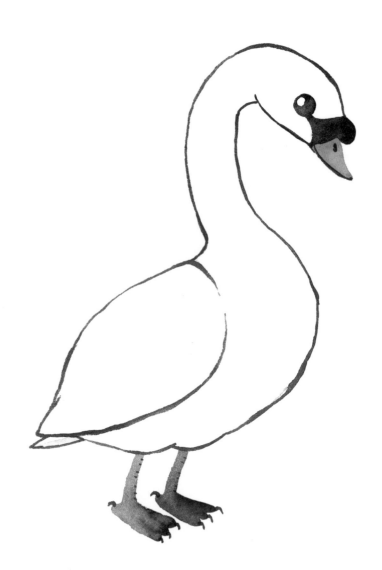

Mute Swan
Cygnus olor

For a bird that is supposedly mute, this graceful and iconic river dweller isn't half a parrot. With grumbles, groans and a pantomime villain's hiss, the Mute Swan is very much an audible presence within the world of birdsong. My most treasured swan song is heard when the cygnets are looking big, confident and fluffy as they follow their proud parents upstream, yet they still have the squeaky voices of week-old puppies.

Canada Goose
Branta canadensis

We all know this Canadian mob from parks
and the riverside, familiar with them putting
on a hustle for bread crusts or just generally
hanging about as if they were people too.
They're not aggressive, they're just trying to fit
in. That's what is immediately striking about
these introduced waterfowl: their friendliness.
You would never catch any other geese being
quite as polite as they arrive at their second
home for the winter months.

As admirable and affable in company as the
Canada Goose is, you can't beat the sight of a
great wedge of them, spread in a V formation
against the autumn sky, 'honking' their heads
off. Like a group of lads between pubs, the
configuration just about holds together,
powered by sheer determination.

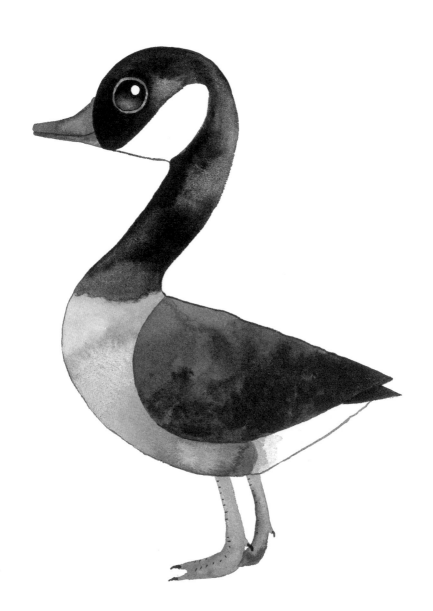

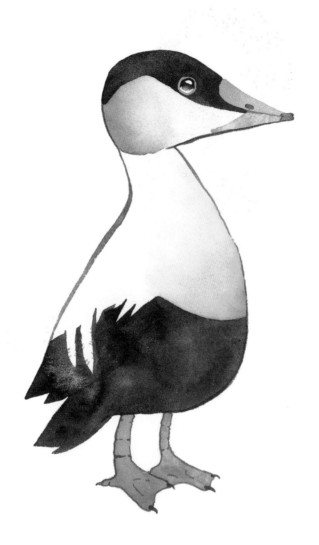

Eider
Somateria mollissima

Found way, way up north, these salt-water
ducks are big old boys with lovely soft
feathers. Their prattle sounds like gossipy
conversation behind another duck's back:
'oohs' and 'aahs' rather than the 'quack quack
quack' we're used to from the irrepressible
Mallards that frequent every neighbourhood
in the UK.

Coot
Fulica atra

Why not a Moorhen? They're prettier, with
a red and yellow head shield, not bald as a
Coot . . . But have you ever seen a Coot's feet?
Exactly! Like weird, scaly, deflated washing-
up gloves, which handily help them to walk on
water (if the water is full of weeds, that is).
The size of a Moorhen wearing a swimming
cap, the Coot is not really known for his call,
but you will recognise it as a loud honk.

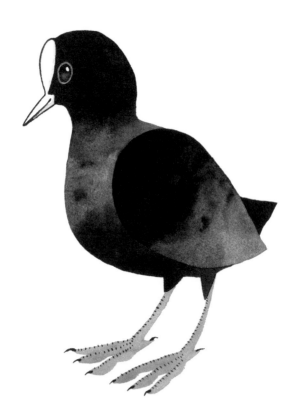

Oystercatcher
Haematopus ostralegus

A sturdy, handsome pied coastal bird with a
taste for all manner of cockles, limpets and
other molluscs. A born romantic who doesn't
rely on his scintillating orange beak, fancy
dancing and aphrodisiacs to lure the ladies;
the Oystercatcher just sings (or shouts, to be
honest) his heart out. It's not the prettiest
of songs by any stretch of the imagination,
but it certainly works.

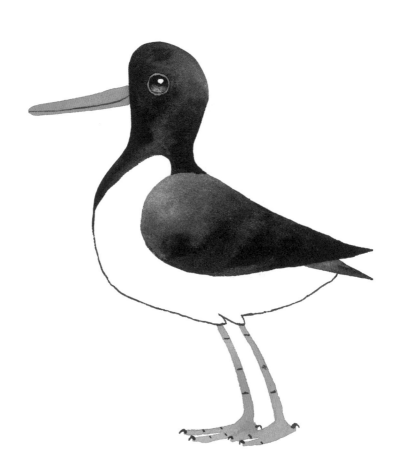

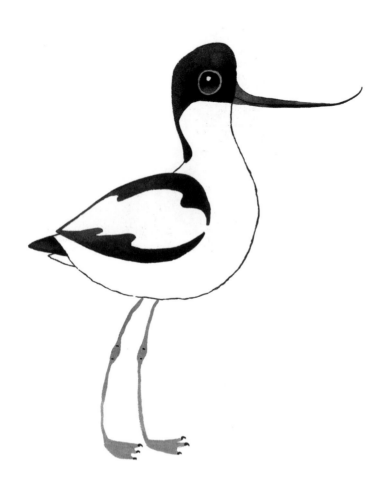

Avocet
Recurvirostra avosetta

Striking, elegant and graceful, the Avocet
belongs on the catwalks of Paris rather than in
the boggy coastal sanctuaries of Suffolk. Alas,
for such a stunner, the call is a croaker, but
then again I bet *you* would sound a bit weird
with your nose pointing upside down.

Snipe
Gallinago gallinago

With a beak like a broom handle, it's not hard
to see why a song isn't always on the lips of a
Snipe. A mottled coat for camouflage rather
than flirting, and a song for conversing rather
than courting, it's the Snipe's aerial flare that
is a hit with the ladies. That 'peep peep peep'
doesn't sound too bad now, does it?

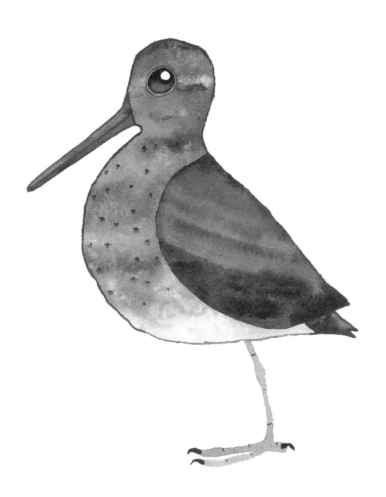

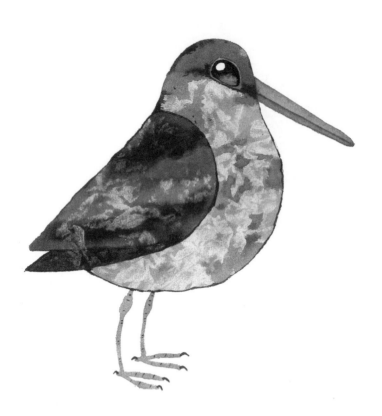

Woodcock
Scolopax rusticola

Something he's eaten doesn't agree with the
Woodcock – you can hear him coming a mile
off: 'Fart fart fart Peep! Fart fart fart Peep! Fart
fart fart Peep!', or a couple of shuffle pumps
and a tommy squeaker, to give the 'song' its
scientific name. It's hard to imagine that this
little set of bagpipes is considered a delicacy
and hunted in many parts of Europe. Best
advice I can give the poor chap is to keep
upwind of the idiots with the shotguns.

Curlew
Numenius arquata

You're lost in the foggy marshes, you hear
a ghostly wail . . . is it the Hound of the
Baskervilles? Cathy searching for Heathcliff?
An American Werewolf in Yorkshire? Nope,
you're probably hearing the melancholy sonnet
of the Curlew. Taking into consideration his
largish size and amazingly long beak, this
estuary bird is quite adept with sound, and
his sad lament has become a favourite with
fishermen and riverside ramblers.

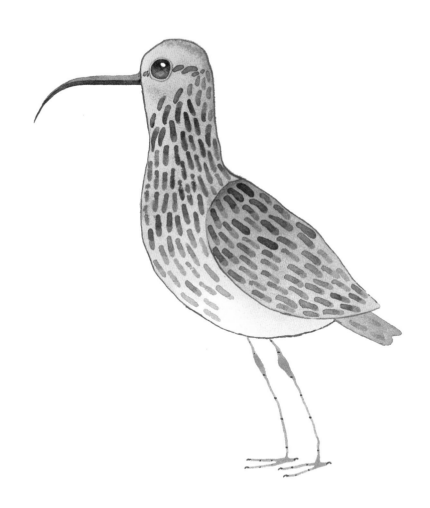

Great Black-backed Gull
Larus marinus

Nature's cruel messenger. Big as an Alsatian
– and keeps growing to the ripe old age of
thirty – with a menacing glare and a fearsome,
permanently blood-stained beak that could
have come from any poor animal, bird or
person. Top of the food chain, nothing is off
the menu for the Great Black-backed Gull.
An ear-splitting 'kee-orr' shriek announces
his arrival, a squall that must have felt like the
most welcoming of serenades to the ears of
sailors returning to dry land after years away
on the high seas.

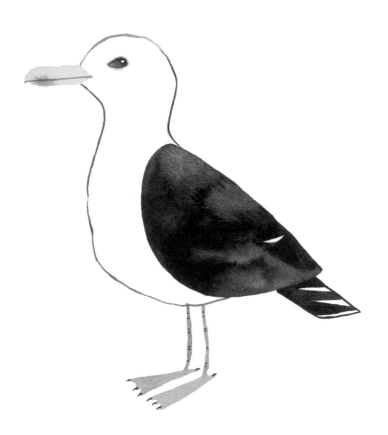

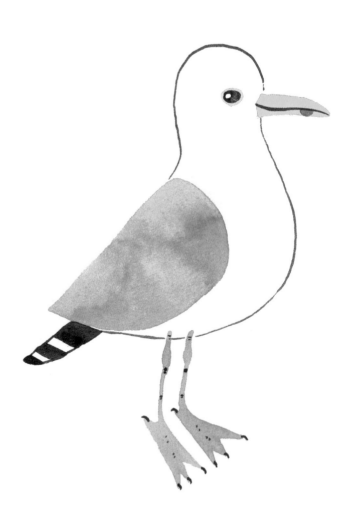

Herring Gull
Larus argentatus

The disturber of peace, the raider of bins,
the mugger of vinegary chips and ice creams,
the wheeling circler of rubbish dumps, and the
sound of a thousand sunny seaside memories.

Kittiwake
Rissa tridactyla

This sweet, inky-fingered seabird, like the
Cuckoo and Chiffchaff, can quite happily talk
about himself all day long. Usually found far
out at sea or in the centre of Newcastle upon
Tyne – a strange home for such a beautiful bird
with a beautiful name.

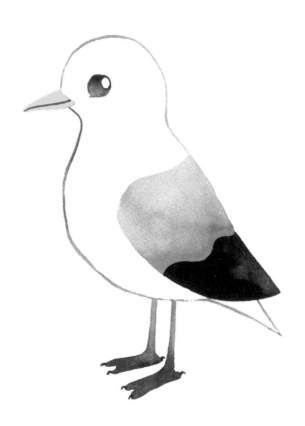

Honey Buzzard
Pernis apivorus

Slimmer in shape and lighter in colour
and tone than the very common Common
Buzzard, whose 'kiiiaaaw'-ing can be heard the
length and breadth of our isles. With honeyed
tones, this buzzard sounds sweeter, like a cat:
'peeeow'. A much rarer and delectable spot for
the trained eye . . . here kitty, kitty.

Golden Eagle
Aquila chrysaetos

Like most big dudes, the Golden Eagle is a man of few words, keeping it for the eyrie only. His wheezy, whistley snore or high-flying yelps during cartwheeling courtship displays aren't really that necessary to identify this magnificent bird of prey. Such an awesome and devastatingly handsome fellow needs no introduction. Rugged, heroic and staunch, spiralling over the Highlands with a wingspan of over two metres, whose contours cut a totem against the sky, the Golden Eagle is such a treasure that even the mountains of Scotland are proud to have him call them home.

Peregrine Falcon
Falco peregrinus

That descending screech is a bell tolling for
some poor pigeon about to be struck by the
lightning bolt that is the Peregrine Falcon.
Not only is it the fastest bird in Britain, it's
the fastest animal on the planet and the only
sentient being that can break the sound barrier.
Originally a cliff dweller and the prized bird in
falconry, selected only for kings and noblemen,
this majestic blue-grey falcon fell out of favour
after the Middle Ages and was persecuted and
poisoned to near extinction. Tragedy closely
averted, numbers have been on the rise and
their distinctive cry can be heard in many
cities, taking up roosts in high-rise blocks,
cathedrals and water towers.

Red Kite
Milvus milvus

It's hard to hear a Red Kite, as it will probably be drowned out by the deafening din of the motorway. Once one of the most common birds of prey in Britain and a symbolic silhouette in medieval skies, the Red Kite was a city scavenger. Imagine what it would have been like if these massive raptors had replaced pigeons – terrifying but awesomely amazing! They were such a common sight that the name for a toy kite actually comes from the bird.

The kites were eventually hunted, poisoned and persecuted until there was nothing left but a Welsh stronghold of a few pairs, secreted away in the lush green valleys. Now, through the reintroduction work of ornithological philanthropists, they are a common sight in some places and block out the sun in others, cheering up many a journey along certain motorways and bus routes of the British Isles.

Little Owl
Athene noctua

This tranquil little fellow can often be found in daylight, meditating on a fencepost or just absent-mindedly watching traffic. Bid him 'Good day' and he will nod his head in respect and reply, 'HullOOO!', before bobbing off and flying low to a quieter spot where he won't be bothered by nosey well-wishers.

He doesn't possess the most famous of nocturnal calls, but he is easily the most polite of all our owls.

Long-eared Owl
Asio otus

With the dirtiest of looks, it's easy to feel as though you're being coldly judged by this debonair, horned owl, brimming with menace – especially as he is looking you up and down, chastising you with an 'oooh' and 'euurrgh'. The Long-eared Owl, arrogant and vain, with every right to be. What a dish!

Owls are deeply engrained in our consciousness. The Tawny Owl's 'too-wit too-woo' is a phrase we learn in childhood and never forget. In bygone times the Barn Owl's chilling shrieks have caused these cute creatures to be perceived as symbolic omens of death.

Raven
Corvus corax

Magpies have a death rattle for a song, the Jay
shrieks like a startled widow, Jackdaws yack,
Rooks cluck and Crows crow. But only the
Raven has a 'kronk'. Rolling his 'r's like a local
yokel, the Raven loves to mouth off high in the
sky above mountains and rocky outcrops,
the guttural command uneasily appreciated by
fell walkers, farmhands and anybody else
in its range.

Capercaillie
Tetrao urogallus

Amongst the pine trees, the blues of the
Scottish Peacock are only witnessed by a lucky
few in arboreal Scotland. Pheasants croak, Red
Grouse bark and Partridges burst out of the
undergrowth shouting 'quick! quick! quick!'.
All game birds are known for their rustic,
Arcadian coats of feathers and their blusterous
outbursts, but none more so than the mighty
Capercaillie, whose muscular courtship display
is accompanied by the strangest of fanfares,
like a ping-pong ball being rattled around an
empty vessel. Honest!

Corncrake
Crex crex

The Corncrake is a mysterious, antiquated water
bird that took a fancy to dry land and never
went back.

Favouring meadows and tall grass, the
clandestine Corncrake is as secretive and
cautious as an elusive Water Rail, imperceptible
amongst the bullrushes and reeds.

His call is just as enigmatic as his curious
nature, a cryptic, clicky oscillation in the fields,
like a mobile phone vibrating in the middle of
the night. But louder and weirder,
much weirder.

Turtle Dove
Streptopelia turtur

A glamorous granny resplendent in lace, doilies and pastel knickerbockers. The Dove's gentle purr could lull even the most active of minds to sleep whilst sitting in the shade of an oak tree. A rare sight that is becoming rarer every summer – they don't make them like that any more. And to think that in some areas of Europe it is actually considered sport to shoot these beautiful birds.

Cuckoo
Cuculus canorus

Kuckuck in German, *Coucou* in French,
Guguk in Turkish and *Côg* in Welsh, he
may have a different accent but he's always
saying the same old thing. Yet our Common
Cuckoo is just one nut in an extensive family
of fruitcakes, which takes in parasitic brooders,
dwarves, parental role swappers and long-
legged ground birds such as the Roadrunner in
America: 'meep-meep!'. No, excuse me Sir,
I think you'll find it's 'cuck-koo!'.

Kingfisher
Alcedo atthis

A bird from the absolute elsewhere, the
Kingfisher is a celestial work of art. So
otherworldly that even he's aware that looking
upon his tiny frame can make mankind ask the
biggest of questions and doubt all that he knows
and has ever been told. So, kindly, he offers us
just millisecond glances or fleeting dashes until
he's off to blow the next yawning mind.

With a miniature cloak of incandescent blue
and a chest orangier than a polished satsuma on
Christmas morning, one would expect a song of
sublime delicacies, an ethereal paean to herald a
gathering of monarchs and magi. Unfortunately,
to be the king of all fishermen requires you
to have a brutal dagger for a mouthpiece,
resulting in a taut, high-pitched whistle of a call.
Disappointing maybe, but study this whine and
you will stand a much better chance of spending
time with the most brilliant of all British birds.

Nightjar
Caprimulgus europaeus

Half Owl, half Swift, half Bat, the Nightjar
is a very strange bird indeed. With nocturnal
habits, big eyes and an even bigger mouth,
the Puck Bird has mystified the human race
for centuries. It was widely believed that the
dude's big mouth was used for stealing milk
from goats rather than catching big, dusty
moths, a suspicion so strong that his Latin
name actually means 'goat sucker'.

Such an otherworldly bird deserves an
altogether esoteric song. Which is a cryptic
drone, a wooden mechanical clockwork
on hyperdrive, like a ghost in a pre-steam
machine. Spooky.

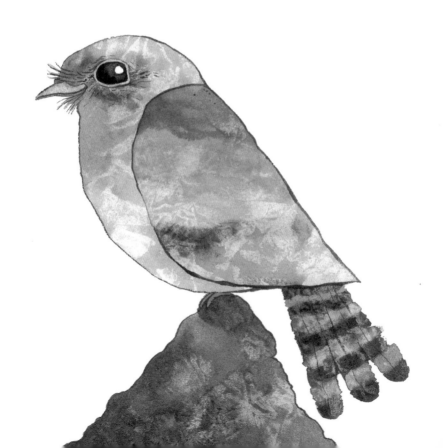

Swallow
Hirundo rustica

Of all the high-flying birds, the Swallow's song is the sweetest. After an epic journey following magnetic energy lines across Europe, the chitter-chatter of House Martins and the arcane screams of Swifts combine with the Swallow's chirrupy song, arriving just in time to create everybody's soundtrack to the summer.

The Swallow's social song is sung on many occasions – up in the blue, in the nest or on telephone wires – but my favourite is heard at the beginning of autumn when all the Swallows have congregated, packed their bags and are heading back on intercontinental airwaves to Africa. The last few young stragglers excitedly bound over the hills together, singing the same song, but this time with sheer joy at the first wingbeats of their first big adventure. Don't forget to send a postcard!

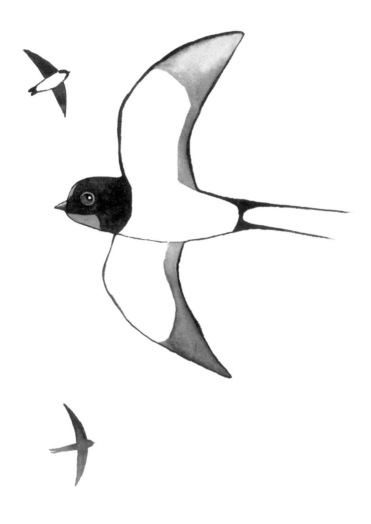

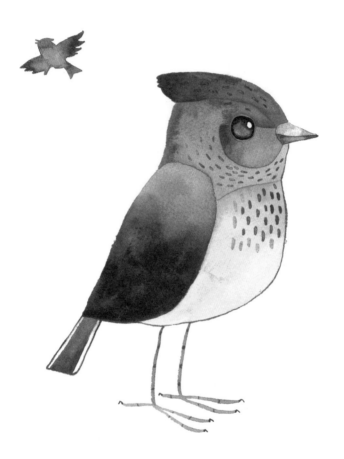

Skylark
Alauda arvensis

There are many sights, sounds and smells of British summertime, and the spotting of Skylarks is a heady, alchemical mix. They fly high and hover above meadows, singing crystalline enchantments before parachuting down into the undergrowth as if protected by the notes. The Lark rises and breaks hearts.

Shorelark
Eremophila alpestris

This foreign devil frequents our eastern shores
from time to time with other Scandinavian
visitors, the Waxwing and Fieldfare. Keeping it
strictly coastal, this fellow sings his song on the
wing like all larks, above the shingle and sea
spray. An amazing winter spot for anybody
to behold, with his sushi chef outfit and
striking tones.

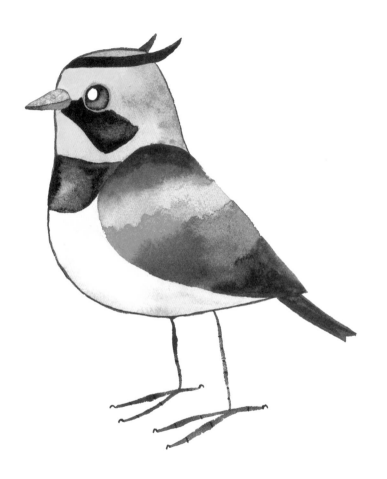

Wren
Troglodytes troglodytes

There are many wrens around the world –
Carolina Wrens, Riflemen, Rock and Bush
Wrens, Splendid Wrens and Blue Fairy Wrens
– but none maybe quite as loud as our
humble, tiny Common Wren. Roughly the
size of a thimble but with a scold that could
scorch earth.

Wood Warbler/Willow Warbler/Chiffchaff
Phylloscopus sibilatrix/
Phylloscopus trochilus/
Phylloscopus collybita

Now, being a man of the world, I don't want
to come across as an abhorrent, bigoted
warblist, but I have a terrible time telling the
difference between a lot of the warblers – they
all look the same. But the trick with many a
warbler is just to sit and listen to what they
are saying and you will immediately hear that
each is an individual with rattles, long, looping
languid songs, sweet peeps, wolf whistles and
chiffchaffings.

Whitethroat
Sylvia communis

Another warbler that is not easy to spot but
is so contrasting to our native warblers that
he's not hard to identify or name; like the
Blackcap, his name is on the tin. Much bigger
and thick-set than the rest of his warbling
brothers, with a gruffer voice and sturdy song
to match. He's not here for long – summer
only – travelling and seeking a temperate
climate away from his home in Africa. Where
I'm sure he fits in a treat.

Garden Warbler
Sylvia borin

A diamond in the rough in every sense,
a diminutive wheaten songbird whose hidden
talent of singing is a closely guarded secret.
Even her Latin name is 'borin', and in true
plain-Jane style she veils herself in the leafy
undergrowth and recites her lovely deep song
– like a shy teenager hidden in her bedroom
singing love songs into a hairbrush. Singing
for themselves.

Which is the very opposite of close family
member the Sedge Warbler, who stands tall and
proud and fires out his scattergun, avant-garde,
never-ending song of non-repetitive peeps into
the marsh. Letting everybody within firing
distance know that he's got a voicebox and
he's gonna use it!

Bearded Tit
Panurus biarmicus

Ping! Ping! Piercing Ping! Almost inaudible,
it must be a nightmare for any dogs that live
in marshes; poor wet dogs driven to madness
by a high-pitched cacophony. An absolute
beauty of a bird: striking eyewear, pastel tones
and long, luxurious tail feathers. Sartorial and
gorgeous. A treasured spot for even the most
dedicated and jaded of bird spotters, never
mind us mere nature aficionados.

Pied Flycatcher
Ficedula hypoleuca

No, he hasn't just caught a fly, those are his
bristly whiskers. An exceptional spot if you
see one, as they are beautiful and infrequent
summer visitors. Oodles of charm with a
cheerful song, though not half as common as
their duller cousin the Spotted Flycatcher, who
sounds more like a squeaky wheelbarrow.

Stonechat
Saxicola torquata

Chat chat chat, indeed. Favouring moorland,
whin bushes and heather, this handsome,
thickly accented, coarse-singing uplander has
an alluring orange chest and an alarming song.
Ever vigilant and vocal, like an Inspector Gorse
advising all his flighty familiars that there is a
weird chap with a pair of binoculars coming
their way – it's probably time to dart further
out of view into the barbs and thistles . . .
Damn you Stonechat and your fastidious ways!

Wheatear
Oenanthe oenanthe

Keeping their distance on fellsides, Wheatears
are like the proverbial mountain peak that
keeps disappearing above and away into the
clouds. If you get close enough to gaze upon
his splendid blue gilet, you could also be
lucky enough to see him perched on a rock
whistling his perky, bright tune.

Meadow Pipit
Anthus pratensis

There are many pipits – Rook, Tawny and
Tree – but the Meadow is a mini Song Thrush
in the making in spirit and looks. Lively and
social with a complicated song that you could
never dream of learning the words to,
so don't even try.

Robin
Erithacus rubecula

Not just for Christmas, the Robin sings his
song all year round, and what a plethora of
numbers these gusty red-breasted folk know:
carols, aggressive fast numbers, golden oldies
and ballads as soft as snow. The Robin's
greatest hits are a treasured possession in many
a garden and park.

Nightingale
Luscinia megarhynchos

He may be a household name, but could
you recognise a Nightingale walking down
the street, or even name one of his tunes?
Didn't think so. The legendary status of the
Nightingale's song has all but eclipsed the
corporeal existence of this rather dull-looking
Robin. But being a shy and retiring individual
I'm sure he doesn't mind that his talents get
all of the limelight, and it doesn't matter how
far into the hedgerow he hides himself, his
luminous molten song will be greeted as a
blessing and glorified in folklore. If you are
lucky enough to hear a Nightingale's song,
treasure it with both ears, hold it in both hands
and tell the world.

Blackbird
Turdus merula

The most common bird in Britain. Originally a woodland bird who has taken to the urban environment like a Kingfisher to water. With reassuring 'clucks' and trumpeted melodies, the Blackbird's songs are appreciated every day and everywhere.

But heaven forbid you accidentally step within ten metres of their nest. A brave Blackbird will meet you eyeball to eyeball and blaze an alarm with the same gusto as the captain of a burning boat singing battle hymns into the face of forty-foot waves. A fearsome siren that is a vital early warning system for all birds in the locality, especially when there's a troublesome cat out stalking. Raise the alarm!

Song Thrush
Turdus philomelos

A true professional in the old-school sense,
a crooning garden favourite who belts out
every number like it's the finale to a grand
show. Poetry, sonnet and life story, his song is
perfected over years, added to and polished and
always delivered with such heartfelt zeal,
it doesn't matter whether he is headlining
at Wembley or singing in the shower.
A songbird in every sense.

Dartford Warbler
Sylvia undata

Like a singing thistle in a bobble hat.
A regular visitor from southern Europe who
only holidays in certain locations and would
never dream of going any further north than
the Dartford Tunnel. A rare groove of
Euro-flavoured melodies graces the gorse
bushes of these lucky boltholes. It's a real
shame for all of us that this warbler isn't
a little bit more adventurous.

Blue Tit
Cyanistes caeruleus

Like all tits, the dextrous Blue Tit is not renowned for its songs, but its high-pitched cheeps, peeps and squeedle-deeps. A reverberation that people are so accustomed to, it's generally ignored in everyday life as we are so ensconced in it, like a feathery comfort blanket.

Being surrounded by a family of Long-tailed Tits and their sharp, pin-prick call is like rolling in nettles if they sang rather than stung. The family that sings together flocks together.

Willow Tit
Poecile montanus

Could also very easily be labelled as a Marsh
Tit as they are practically the same bird but
with the slightest difference in marking, but
I went for the Willow as I prefer the name. Plus
you don't actually find Marsh Tits in marshes.
You don't find Willow Tits exclusively in
willow trees either, but we'll let that one slip.
Both of these birds and their 'zee-zee'-ing
calls are regular spots on rainy walks up rocky,
woodland hills.

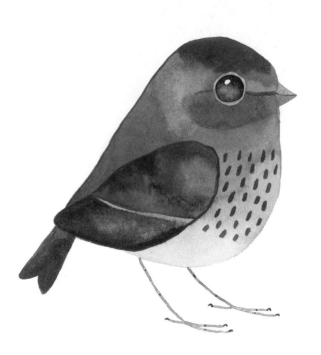

Twite
Carduelis flavirostris

Or Pennine Finch, a local bird for local people.
Nothing much to look at: a faded Linnet or
rejected Redpoll. A plain northern bird that is
definitely a finch in cuteness and stature, but
does her own thing and sings her own song,
a song so personal she is named after it. There
is more to the Twite than meets the eye.

Bullfinch
Pyrrhula pyrrhula

Eavesdrop on a Bullfinch and you will hear
a simple but melancholic song: two minor
chords plucked on a harp. We all know the sad
ones are the finest ones. Best appreciated on a
crisp, blue-sky winter's day.

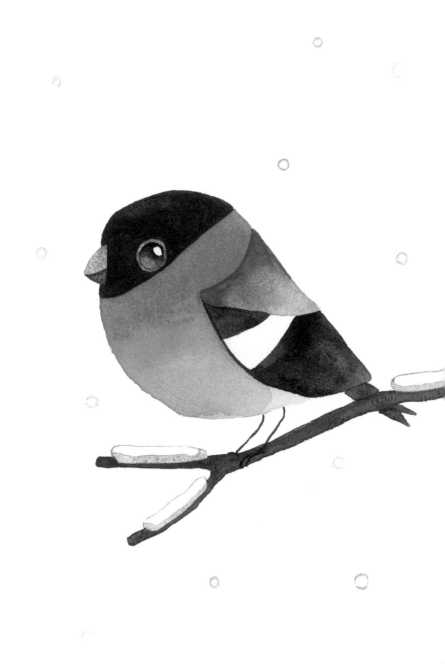

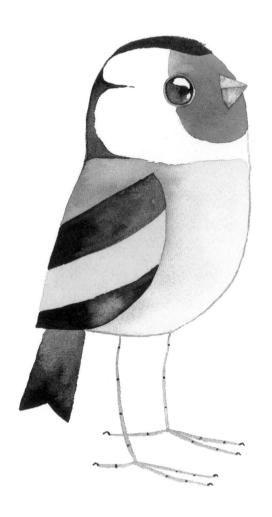

Goldfinch
Carduelis carduelis

Finches have many calls, alarms and greetings.
My favourite one of all is the squeaky chatter
of a charm of Goldfinches; family and friends
bond within an applause of bouncy squeaks,
as though it is their sheer pleasure to sing
and belong to a chorus. Unfortunately, the
Goldfinch is one of the only British birds that
sings whilst caged; listeners would revel in the
array of sounds and beauty when actually
the finch was pining for his charm.

Dipper
Cinclus cinclus

A fat Wren? A wrong Robin? A suicidal
Sparrow? A mixture of all? It's easy to get
confused by a Dipper as he is an anomaly
amongst our songbirds, preferring to spend
most of his time running around feeding
underwater. He bobs about from stone to
boulder, quick as a ball stolen by the current,
all the time reciting his immaculate,
crystal-clear song that he learnt note by note
from the river.

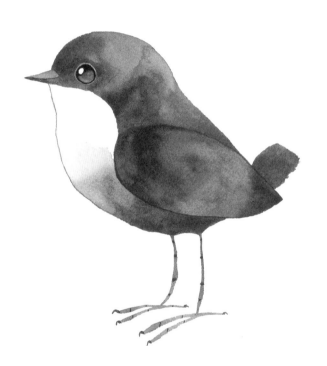

Yellowhammer
Emberiza citrinella

All buntings are jittery jibber-jabbers, keeping
the meadows, hedgerows and hillside updated
about the slightest detail with nervy, high-
pitched chatter and signals. The Yellowhammer
is no different, a keen prattler and doom-
monger who also loves to sing his lunch order
of a flustered 'a little bit of bread and no
cheese!' It ain't all bad news then . . .

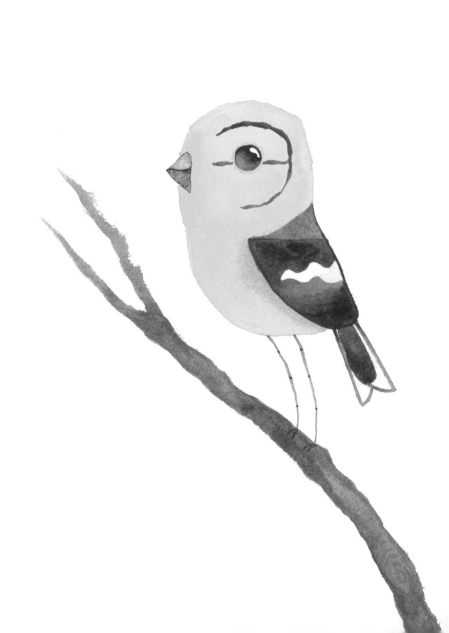

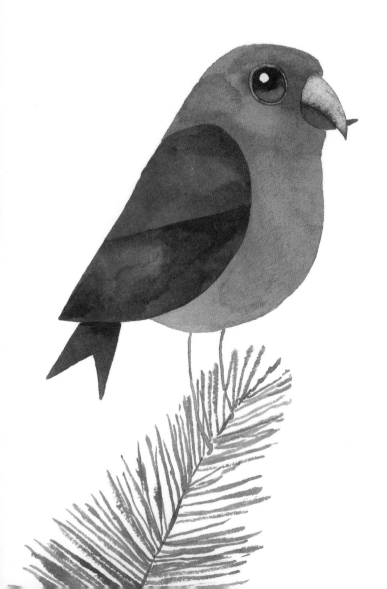

Crossbill
Loxia curvirostra

My maths teacher used to ask me how I would tell jokes with no teeth. Likewise with this chap, how's he going to sing with crossed chops? Not very well, is the answer on both occasions.

The Crossbill is a Scandinavian Alpine Finch, a winter visitor that has taken up residency in the arboreal beauty spots of Scotland and northern England. His beak is designed like a twisty corkscrew for popping pine kernels and not for serenading the green lady Crossbills, so his vocal repertoire is restricted to an occasional 'chup-chup'. He's got the scarlet jacket and the multipurpose beak, but you can't have it all.

Starling
Sturnus vulgaris

This scraggly, oily, unsociable gang member is actually one of the most gifted of our songbirds. With all manner of high-pitched peeps and chirps, curious knocks, rattles and buzzes, the Starling provides a constant supply to the white noise of everyday life. Like only a small pawful of UK birds, it's with the Myna bird-like wizardry of mimicry that the underdog Starling truly becomes a Great British star. With an ear for other tunesmiths he can imitate the House Sparrow, Lapwing, car alarms, telephones, and does a cracking Blackbird. An abhorred nuisance and a righteous, bona fide polymath of birdsong.

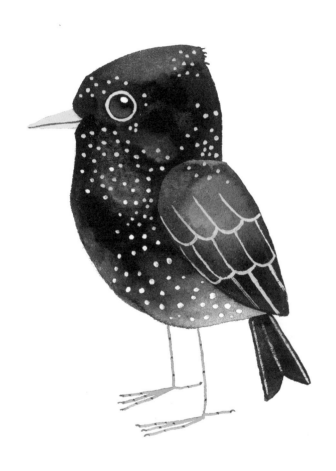

SPOTTING AND JOTTING

It's great spotting a bird you've never seen before, so here's a handy way of keeping all your jottings in check. Get spotting either by sitting comfortably at your window, or pull on some boots, grab a flask and binoculars, and go outside. Happy spotting!

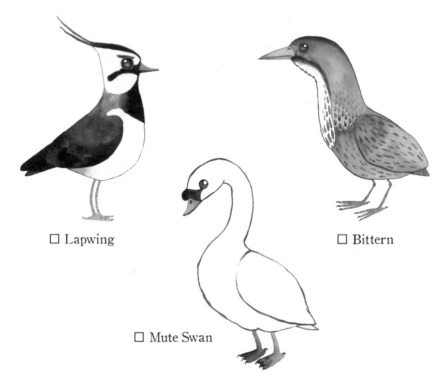

☐ Lapwing

☐ Bittern

☐ Mute Swan

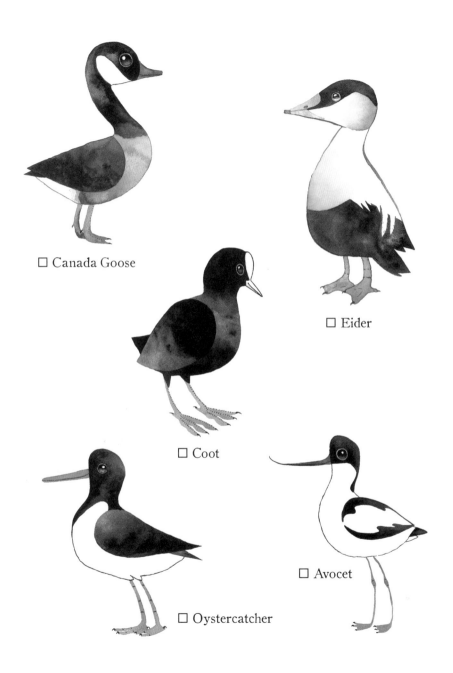

☐ Canada Goose

☐ Eider

☐ Coot

☐ Oystercatcher

☐ Avocet

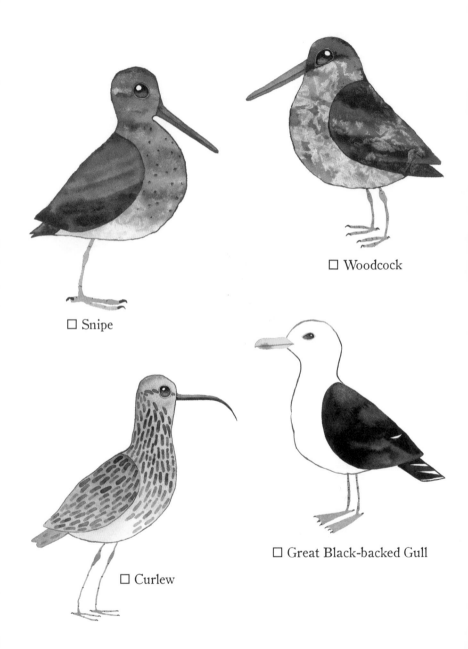

☐ Woodcock

☐ Snipe

☐ Curlew

☐ Great Black-backed Gull

☐ Herring Gull

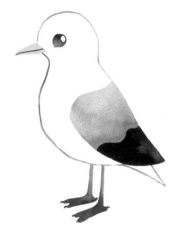

☐ Kittiwake

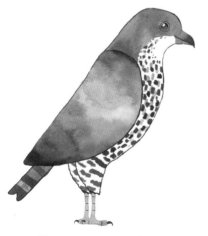

☐ Honey Buzzard

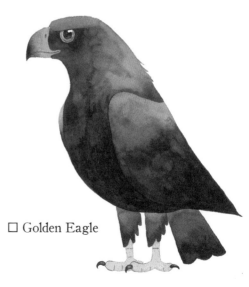

☐ Golden Eagle

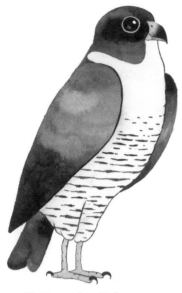

☐ Peregrine Falcon

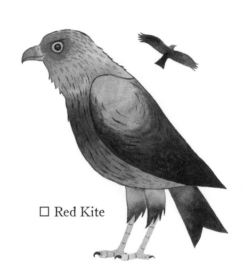

☐ Red Kite

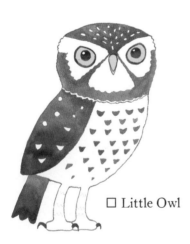

☐ Little Owl

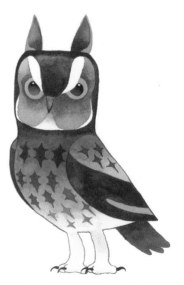

☐ Long-eared Owl

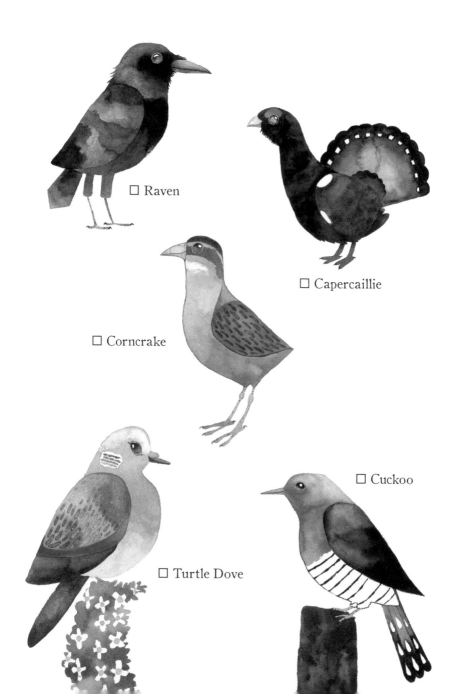

☐ Raven

☐ Capercaillie

☐ Corncrake

☐ Cuckoo

☐ Turtle Dove

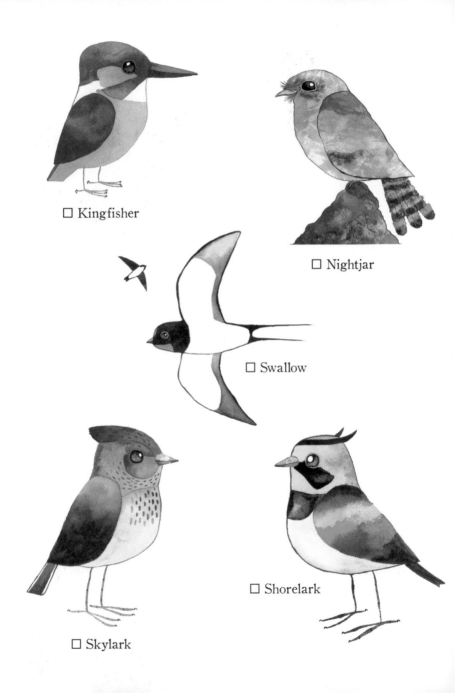

☐ Kingfisher

☐ Nightjar

☐ Swallow

☐ Skylark

☐ Shorelark

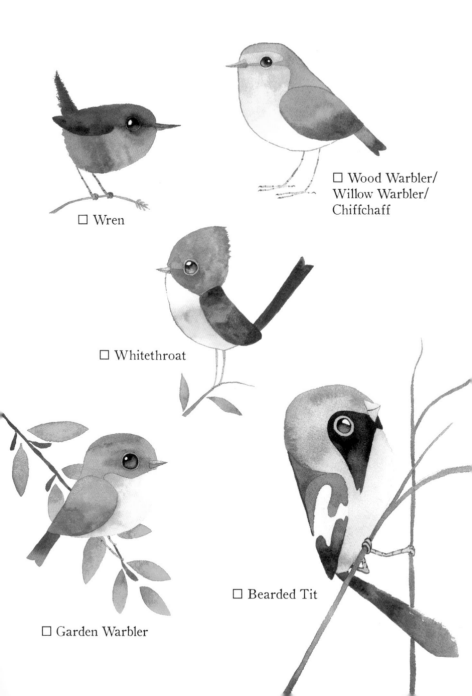

☐ Wren

☐ Wood Warbler/
Willow Warbler/
Chiffchaff

☐ Whitethroat

☐ Garden Warbler

☐ Bearded Tit

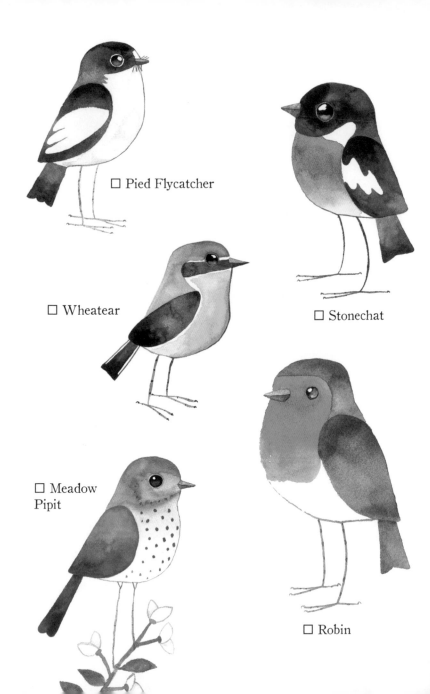

☐ Pied Flycatcher

☐ Wheatear

☐ Stonechat

☐ Meadow Pipit

☐ Robin

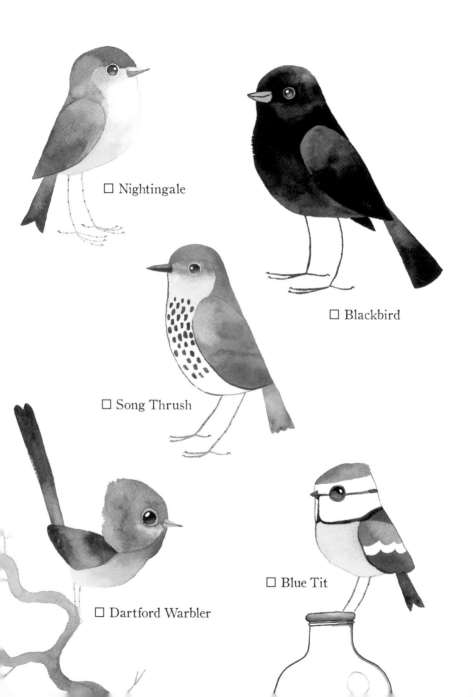

☐ Nightingale

☐ Blackbird

☐ Song Thrush

☐ Dartford Warbler

☐ Blue Tit

☐ Willow Tit

☐ Twite

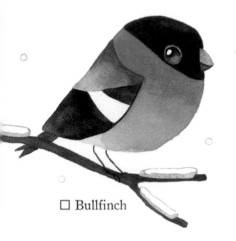

☐ Bullfinch

☐ Goldfinch

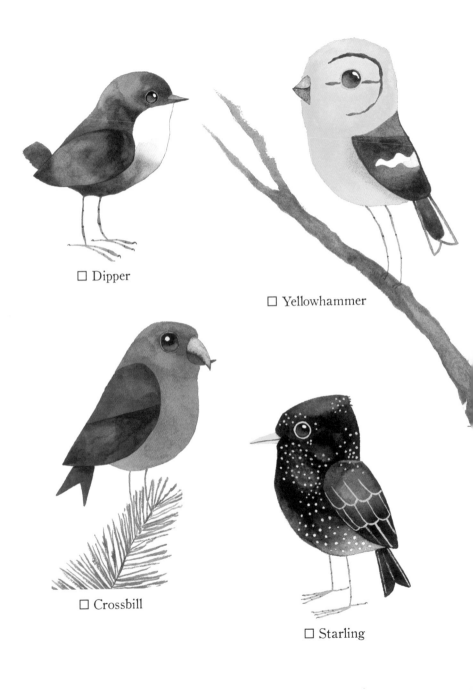

☐ Dipper

☐ Yellowhammer

☐ Crossbill

☐ Starling

ACKNOWLEDGEMENTS

Thank Yous.
The Goldfinches, for everything.
The Sewells, The Lees and The Roses.
Tim the Jay, Rob Avery, Graunty Christine and
her squeaky wheelbarrow. Jimi the Nuthatch.
Matthew the Horse's Kite fables, Simon
Benham, Matthew Clayton, Jeff, Andrew
and Robin at Caught by the River and the
Rooks at Heavenly.
The team at Gas as Interface, and all my
friends in London, Brighton, Shrewsbury,
Manchester and Melbourne!

Special big thanks to Adam and Meg, Leo,
Rach, Gaz, Matt and Jo, Ben and their families.
The Graunties, Me Tommo You Jane, Adam
and Nora, Desi and the Sims, Nick Fraser,
Danny and Joanne, Zenny, The Stones, Rich
and Cath, Ben and all at Spearfish, JK, Sam
Coxon, The Cranes, Em and Anthrax, Stevie
Neasden, Pinky, Lonny and Cosmo, The Flies,
Tom and Claire and The Marauder.